HOW TO DRAW ENDANGERED ANIMALS

Illustrated by
Georgene Hartophilis

Copyright © 1991 Kidsbooks, Inc.
7004 N. California Ave.
Chicago, Il. 60645

Introduction

This book will show you some easy ways to draw many animals that are endangered. Some may be more difficult than others, but if you follow along, step-by-step, you'll soon be able to draw these and others as you continue to learn about wildlife in danger.

Using the basic shapes illustrated below will help you get your drawing started. Remember that these shapes, in different sizes and combinations, will change from animal to animal. Variations of these shapes will also be used.

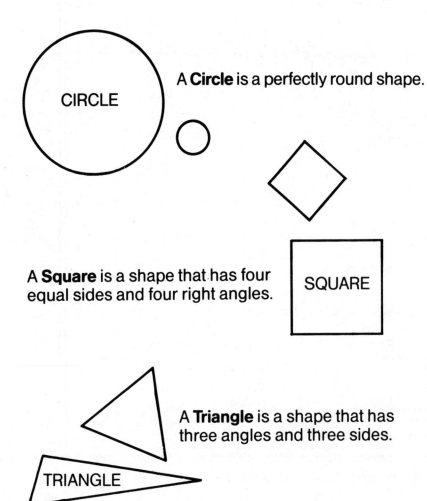

A **Circle** is a perfectly round shape.

A **Square** is a shape that has four equal sides and four right angles.

A **Triangle** is a shape that has three angles and three sides.

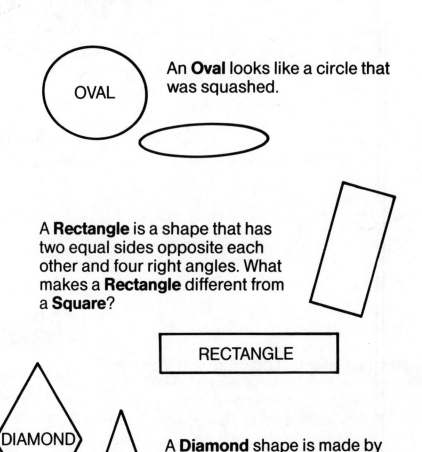

An **Oval** looks like a circle that was squashed.

A **Rectangle** is a shape that has two equal sides opposite each other and four right angles. What makes a **Rectangle** different from a **Square**?

A **Diamond** shape is made by putting two **Triangles** together at their bases.

Supplies

NUMBER 2 PENCILS
SOFT ERASER
DRAWING PAD
FELT-TIP PEN
COLORED PENCILS, MARKERS,
 OR CRAYONS

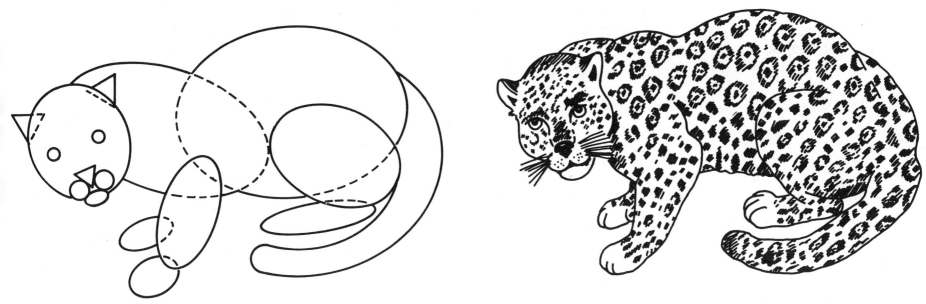

Helpful Hints:

Before starting your first drawing, you may want to practice tracing the different steps. Start your drawing by lightly sketching out the first step. The first step is very important and should be done carefully. The second step will be sketched over the first one. Next, refine and blend the shapes together, erasing any guidelines you no longer need. Add final details, and when your drawing is complete, go over your pencil lines with a felt-tip pen. If you wish, you may color your drawing with markers, pencils, or crayons.

Each endangered animal in this book has special characteristics that make it easier or, in some cases, more difficult to draw. However, it's easy to draw anything when you break it down into simple shapes! Remember, practice makes perfect, so keep drawing until you've mastered each of these special animals. Use your imagination and add elements of each animal's habitat to your drawing.

Animals are endangered when they are on the brink of extinction. Species are considered extinct when their existence is not reported for at least 50 years.

The best known example of extinction was the disappearance of the dinosaurs 50 to 75 million years ago. But, scientists estimate that dinosaur species died off at the rate of only one species per 1,000 years. Today, it is estimated that nearly 1,000 plant and animal species become extinct every year! In the last 300 years, over 300 vertebrate (animals with backbones) animals have become extinct. Some scientists believe that by the year 2000 jungles may no longer exist, thereby reducing the world's animal and plant populations by half.

WHAT'S BEING DONE?

Now, more than ever before, people are becoming aware of the plight of endangered animals, and a greater effort is being made to preserve earth's wild resources.

•• Conservationists are increasing endangered species' populations by breeding and raising them in captivity.

•• When possible, endangered animals are being reintroduced to their natural habitat.

•• Worldwide, protected lands have been set aside where animals can live without the threat of being hunted.

•• Hunting is now regulated in most areas and outlawed entirely in others.

•• People are being educated about the vital role all living things play in our delicately balanced ecosystem.

The animals you'll learn to draw in this book are threatened and endangered. To find out some of the reasons why, look at the chart below.

	overhunted for food, fur, by-products, horns, etc.	threatened by poachers	loss of food supply	reduced habitat, urbanization	slow birth rate	pollution of habitat
Bactrian Camel				X	X	
Rhino	X	X		X	X	
Humpback Whale	X				X	X
Giant Panda	X		X	X		
Komodo Dragon	X					
Indri				X		
Florida Manatee				X	X	X
California Condor			X	X	X	
Jaguar	X	X		X		
Asian Elephant	X	X	X	X		
Red Wolf		X	X	X		
Mountain Gorilla	X	X	X	X	X	
Scimitar-horned Oryx	X					
Tiger	X	X	X	X		
Galapagos Tortoise	X	X	X	X		

Bactrian Camel

Camels can travel great distances without food or water, living off the reserves of fat which are stored in their humps. A few small, wild herds of this two-humped camel still exist in the remote corners of Asia's Gobi Desert.

Flash fact: *Only 300-500 Bactrian Camels survive today. One calf is born to an adult female every other year.*

1. Start with a large, egg-shaped oval for the body. Add smaller ovals for the humps and head. Be sure to draw the basic shapes and connecting lines lightly. These guidelines will be erased later.

Add

Connecting lines

Connecting lines

2. Next, add more oval shapes for the legs and feet. Draw the tail as shown.

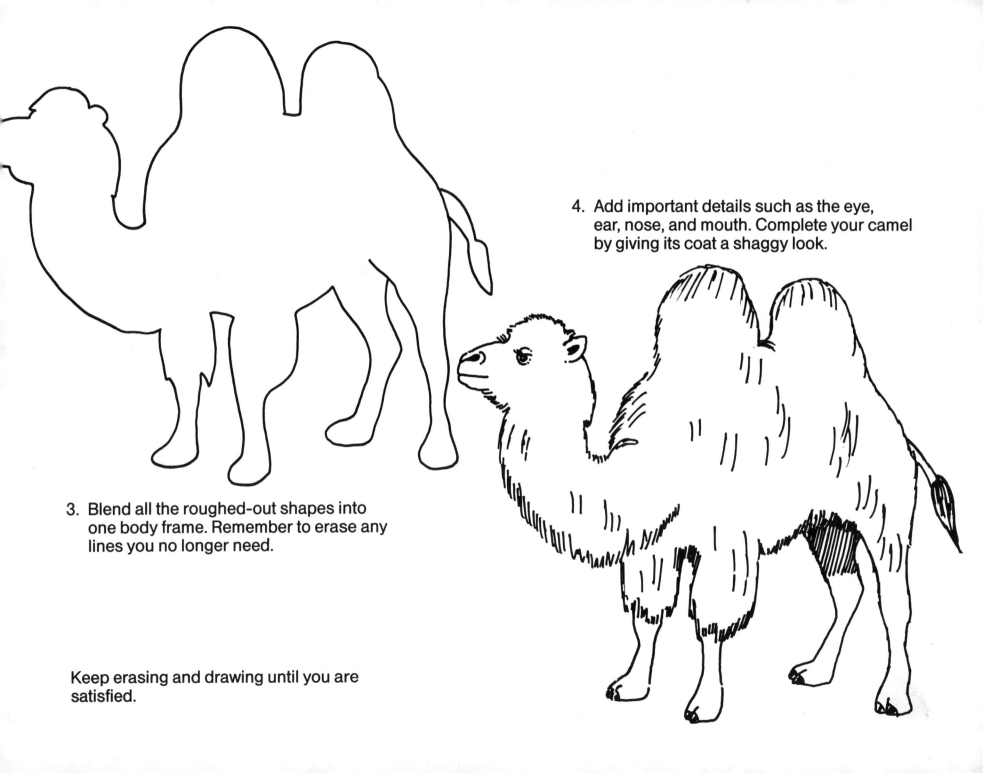

4. Add important details such as the eye, ear, nose, and mouth. Complete your camel by giving its coat a shaggy look.

3. Blend all the roughed-out shapes into one body frame. Remember to erase any lines you no longer need.

Keep erasing and drawing until you are satisfied.

Black Rhinoceros

Rhinos can measure 13 feet in length and weigh up to 5,000 pounds. They have poor eyesight, but possess an excellent sense of smell and keen hearing. Although bulky in size, rhinos are agile and can stop short to quickly change direction. A rhino can run as fast as a horse, about 35 miles per hour!

The Black Rhinoceros can be found in the grassland, bush, and forest areas of Africa.

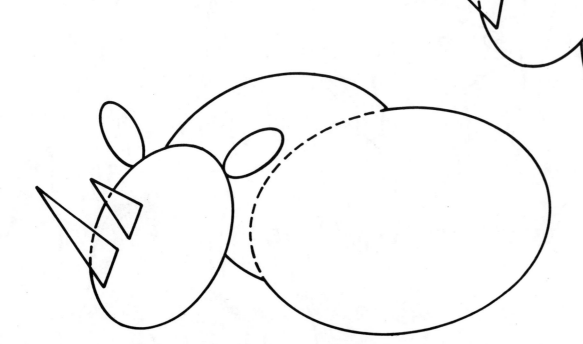

Connecting lines

2. Draw guidelines for the legs and tail and add connecting lines.

1. Begin with lightly-drawn ovals for the body, head and ears. Add triangle shapes for the horns.

Note: It's easier to draw the largest shape first, then the smaller ones.

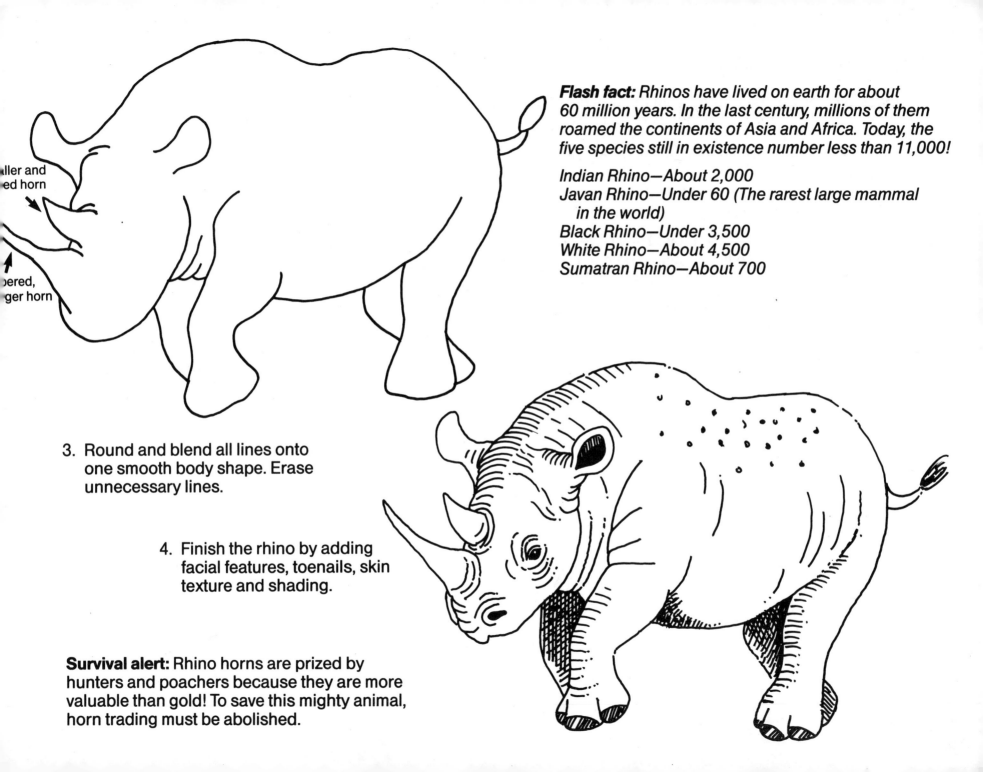

...ller and
...ed horn

...bered,
...ger horn

Flash fact: *Rhinos have lived on earth for about 60 million years. In the last century, millions of them roamed the continents of Asia and Africa. Today, the five species still in existence number less than 11,000!*

Indian Rhino—About 2,000
Javan Rhino—Under 60 (The rarest large mammal in the world)
Black Rhino—Under 3,500
White Rhino—About 4,500
Sumatran Rhino—About 700

3. Round and blend all lines onto one smooth body shape. Erase unnecessary lines.

4. Finish the rhino by adding facial features, toenails, skin texture and shading.

Survival alert: Rhino horns are prized by hunters and poachers because they are more valuable than gold! To save this mighty animal, horn trading must be abolished.

Humpback Whale

Humpback Whales get their name from the way they curve their backs above the surface of the water just before they dive below. This is called "breaching." They are known for their underwater "singing" which can last for as long as twenty minutes. Humpbacks have the longest fins of any whales, measuring up to 14 feet in length. Humpbacks can grow up to 60 feet and weigh over 40 tons.

Humpback Whales are baleen whales. They have no teeth. Instead, they have comblike filters, called baleen plates, attached to their upper jaws which are used strain tiny plants and animals from the water.

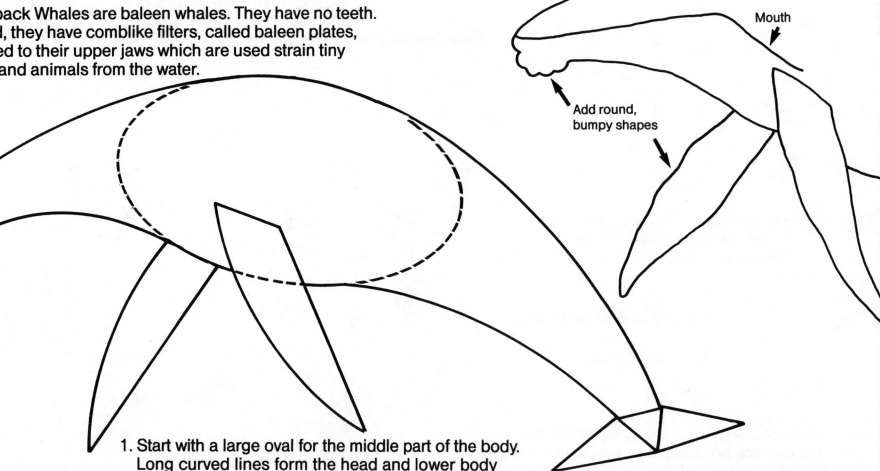

2. Blend all the lines into a continuous smooth shape. Add a curved line for the mouth.

Mouth

Add round, bumpy shapes

1. Start with a large oval for the middle part of the body. Long curved lines form the head and lower body sections. Use triangular shapes for the front flippers and tailfins.

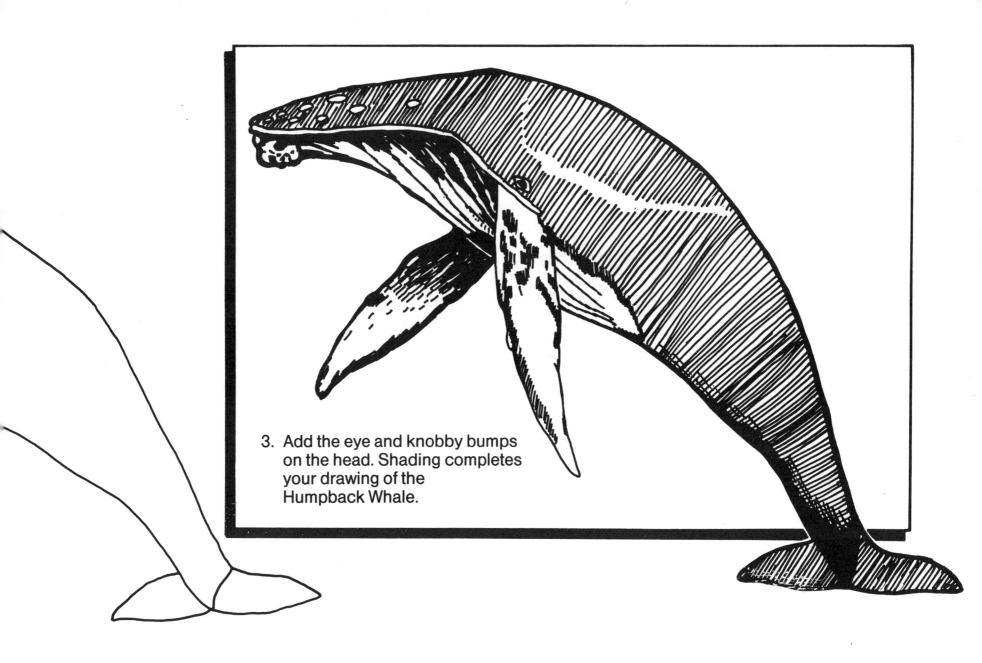

3. Add the eye and knobby bumps on the head. Shading completes your drawing of the Humpback Whale.

Note: The Humpback is easy to draw. Remember to keep all your lines long, giving the whale a graceful look.

Flash fact: Humpback Whales have been protected since 1946. Fewer than 7,000 exist today. Humpbacks bear only one calf every 2-3 years, limiting the possibility of increasing their numbers.

Giant Panda

Giant Pandas are very rare animals that live only in the forests of central China. They grow to 6 feet and can weigh 300 pounds. These gentle animals are vegetarians and consume 25 pounds of bamboo shoots and stems daily.

In 1976, 140 Giant Pandas perished from starvation because their main food supply—bamboo, which takes years to regenerate itself—wasn't available. One species of bamboo, called cold arrow, takes 20 years to grow back!

1. Draw a large oval for the panda's body, and smaller ones for the head, snout, nose and ears.

Connect

Connect

2. Add oval guidelines for the legs and paws.

Note: Always draw guidelines lightly. If you don't like the way something looks, erase and try again.

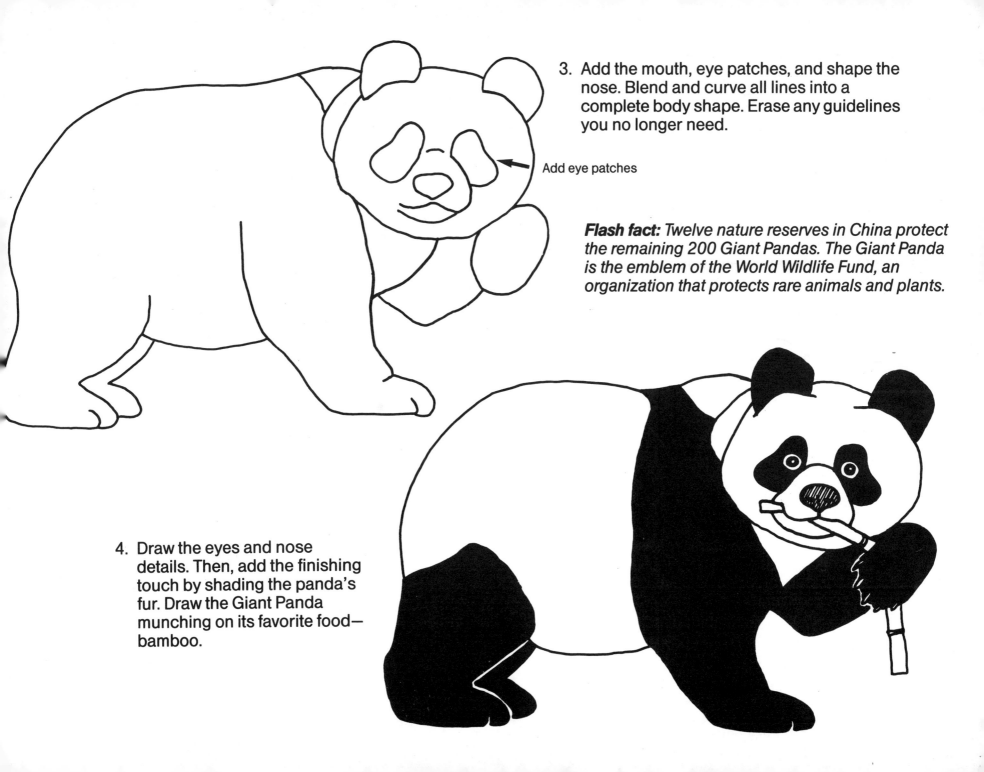

3. Add the mouth, eye patches, and shape the nose. Blend and curve all lines into a complete body shape. Erase any guidelines you no longer need.

Add eye patches

Flash fact: *Twelve nature reserves in China protect the remaining 200 Giant Pandas. The Giant Panda is the emblem of the World Wildlife Fund, an organization that protects rare animals and plants.*

4. Draw the eyes and nose details. Then, add the finishing touch by shading the panda's fur. Draw the Giant Panda munching on its favorite food— bamboo.

Komodo Dragon

The largest of the monitor lizards living today, the Komodo Dragon is a 10-foot-long, 300-pound reptile that lives on the island of Komodo and on a few other small Indonesian islands.

One blow from this predator's tail can kill. Its weight, razor-sharp claws and teeth make the Komodo Dragon a formidable enemy of small mammals and water buffalo. These lizards smell with their constantly flicking, pale yellow tongues.

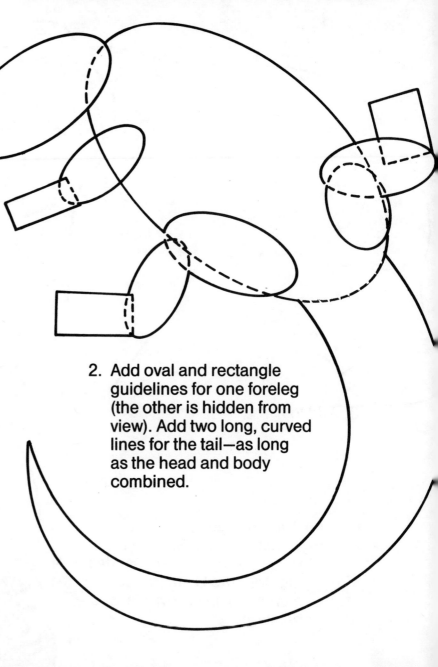

2. Add oval and rectangle guidelines for one foreleg (the other is hidden from view). Add two long, curved lines for the tail—as long as the head and body combined.

1. Begin by drawing a large oval for the body and a smaller oval for the head. Next, draw ovals and rectangles for the hind legs.

Hint: Draw all the lines lightly in steps one and two. They are only guidelines and will be erased.

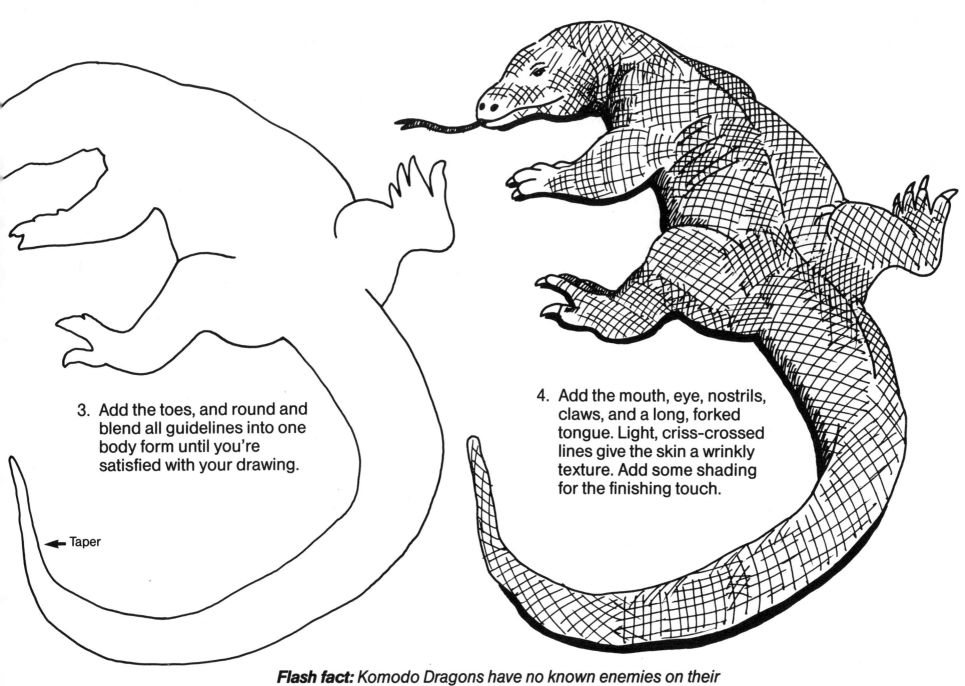

3. Add the toes, and round and blend all guidelines into one body form until you're satisfied with your drawing.

Taper

4. Add the mouth, eye, nostrils, claws, and a long, forked tongue. Light, criss-crossed lines give the skin a wrinkly texture. Add some shading for the finishing touch.

Flash fact: *Komodo Dragons have no known enemies on their native islands—man has been the only threat to their existence.*

Florida Manatee

This shy, gentle water mammal is also known as the Sea Cow. Spending its entire life in warm, sheltered waters, a 12-foot manatee can eat up to 100 pounds of vegetation daily. Manatees can weigh up to 3,000 pounds but have a 1-pound brain!

1. Begin with ovals for the body, head, snout, tail and fins. Dotted lines will be erased, so draw them lightly.

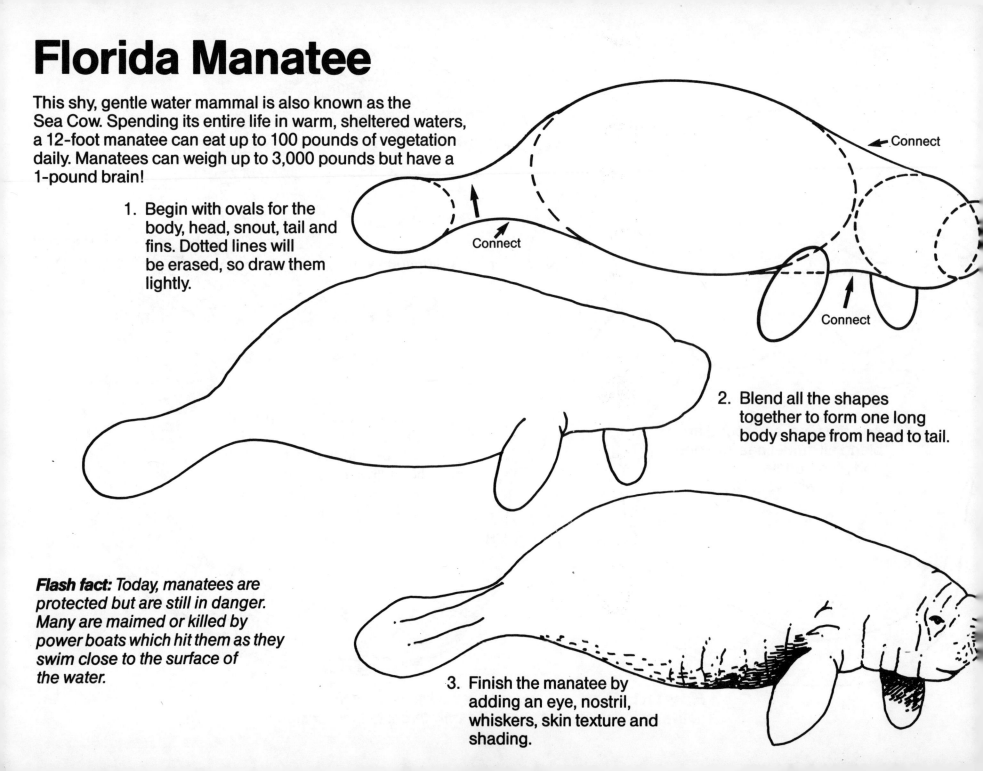

Connect

Connect

Connect

2. Blend all the shapes together to form one long body shape from head to tail.

Flash fact: Today, manatees are protected but are still in danger. Many are maimed or killed by power boats which hit them as they swim close to the surface of the water.

3. Finish the manatee by adding an eye, nostril, whiskers, skin texture and shading.

California Condor

The California Condor is extinct in the wild. Listed as endangered since 1967, a valiant effort has been made to breed these extraordinary birds in captivity and reintroduce them to their natural habitat.

With a wingspan of over 10 feet, condors can soar effortlessly for hours. They are the largest birds in North America.

Survival alert: Condors raise only 1 chick every other year. In 1988, the first California Condor was born in captivity at the San Diego Wildlife Park. It was fed with a hand puppet that resembled an adult condor. The condors living in captivity will eventually be returned to the wild.

1. Start with a narrow oval guideline for the body. Add a small oval for the head, and a curved, triangular shape for the tail. Connect long, curved lines to the body to form the wings and a series of triangles at the end of each wing for feathers.

Connect

Add triangle

Connect

2. Blend all the shapes into one body outline. Erase any guidelines you don't need.

Wavy line

3. Complete the condor by drawing lots of short lines with curved edges to define the body and tail feathers.

Add eye

Complete beak

Flash fact: *California Condors flourished a century ago when vast cattle ranches offered a regular food supply.*

Indri

Indris belong to the lemur family. They only live on preserves set up to protect them on the island of Madagascar. Loss of their forest habitat has reduced the already small numbers of Indris.

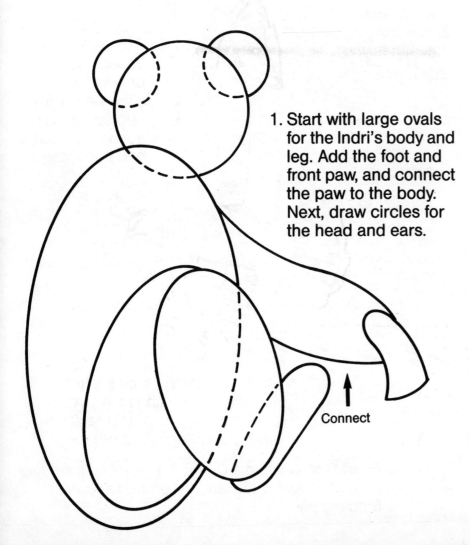

1. Start with large ovals for the Indri's body and leg. Add the foot and front paw, and connect the paw to the body. Next, draw circles for the head and ears.

Connect

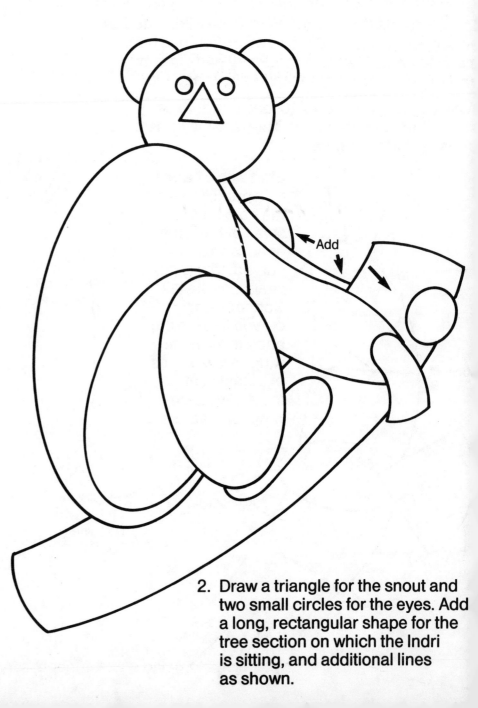

Add

2. Draw a triangle for the snout and two small circles for the eyes. Add a long, rectangular shape for the tree section on which the Indri is sitting, and additional lines as shown.

Flash fact: *Indris are not being bred in captivity. Fewer than 100 exist today.*

Indris live in jungle treetops and eat mostly fruits and leaves. They are only 3 feet tall but they make the loudest, shrillest sound of any animal on Madagascar. The Indri's cry can be heard for miles.

3. Round and blend all shapes into a continuous body form.

Shape fingers

4. Complete the facial features, and add the fingers and toes. Finish the drawing by adding the shading that gives the Indri's coat a dramatic look.

Note: Don't forget to erase unnecessary guidelines.

Jaguar

Hunted for years for its beautiful coat, Jaguars are now a protected species. Due to the ever-shrinking forests of Central and South America, the number of Jaguars is decreasing with each passing year. Jaguars are fiercely protective of their territory, and are excellent hunters, swimmers, and swift runners.

1. Begin with a series of lightly drawn, interconnecting ovals as shown.

Unlike other spotted cats, the Jaguar's spots are enclosed by a circular pattern.

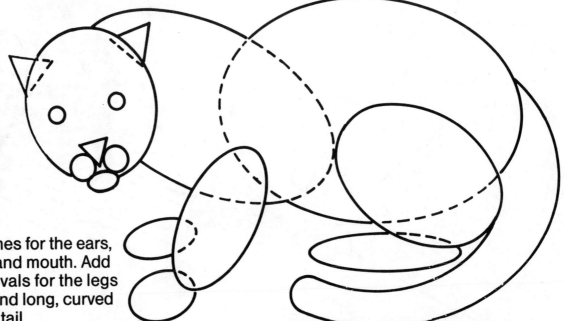

2. Add guidelines for the ears, eyes, nose and mouth. Add additional ovals for the legs and paws, and long, curved lines for the tail.

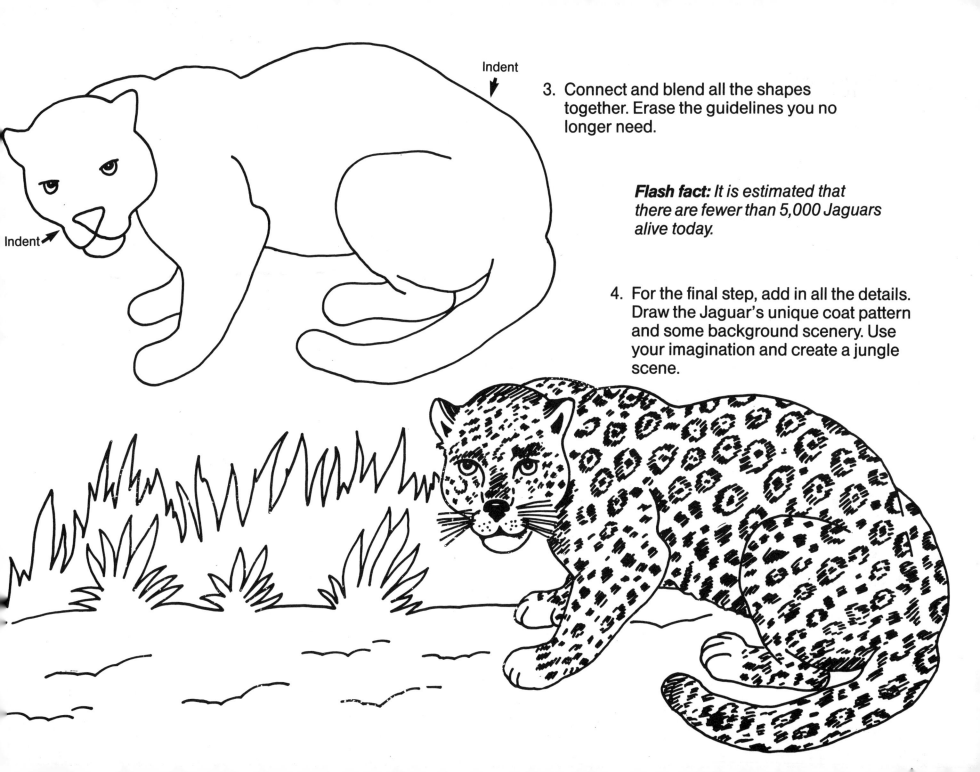

Indent

Indent

3. Connect and blend all the shapes together. Erase the guidelines you no longer need.

Flash fact: *It is estimated that there are fewer than 5,000 Jaguars alive today.*

4. For the final step, add in all the details. Draw the Jaguar's unique coat pattern and some background scenery. Use your imagination and create a jungle scene.

Asian Elephant

Smaller than its African cousin—with smaller tusks and ears—this highly intelligent animal is still used as a work animal in Southeast Asia. Its numbers have been rapidly diminishing due to overhunting and loss of habitat. An Asian Elephant requires 350 pounds of food—grass, bark and twigs—and 20 gallons of water each day.

Survival alert: It is now illegal to import ivory into the United States and many nations in Europe.

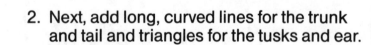

2. Next, add long, curved lines for the trunk and tail and triangles for the tusks and ear.

 Keep drawing and erasing until you are satisfied.

Connect

1. Start with a large oval guideline for the elephant's body. Add a circle for the head and an oval for the hindquarter. Add additional ovals for the feet and connect them to the body.

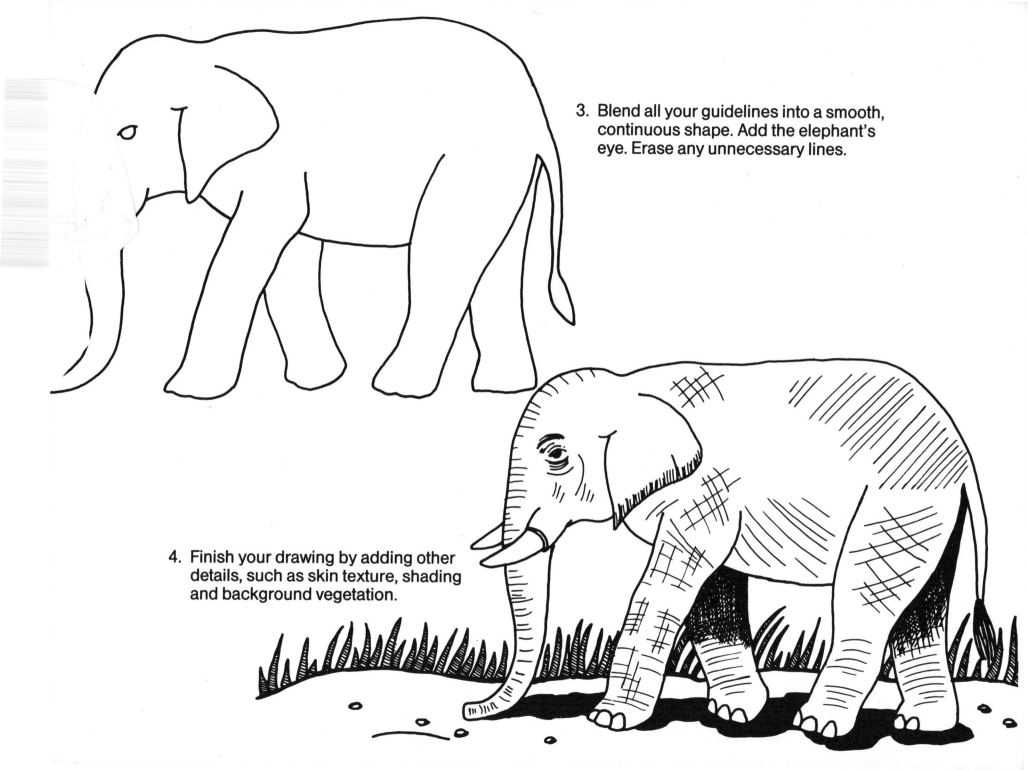

3. Blend all your guidelines into a smooth, continuous shape. Add the elephant's eye. Erase any unnecessary lines.

4. Finish your drawing by adding other details, such as skin texture, shading and background vegetation.

Red Wolf

Because wolves were greatly feared by farmers and ranchers, many of these striking animals were shot, trapped and poisoned. The natural habitats of Red Wolves—areas with heavy vegetative cover—are shrinking dramatically.

Survival alert: *In the United States over 50 Red Wolves are held in captivity by the U.S. Fish and Wildlife Service. It is suspected that red wolves in the wild interbred with coyotes, so the breed is no longer pure. However, 4 pairs of true Red Wolves were released back into the wild in 1987 in North Carolina.*

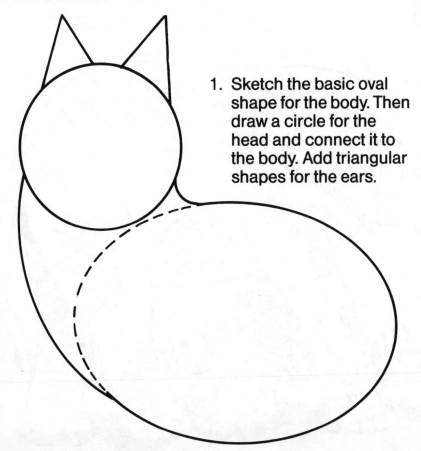

1. Sketch the basic oval shape for the body. Then draw a circle for the head and connect it to the body. Add triangular shapes for the ears.

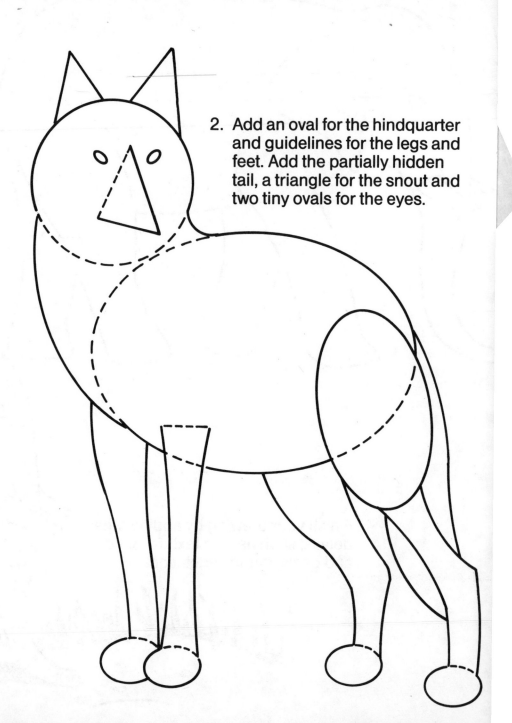

2. Add an oval for the hindquarter and guidelines for the legs and feet. Add the partially hidden tail, a triangle for the snout and two tiny ovals for the eyes.

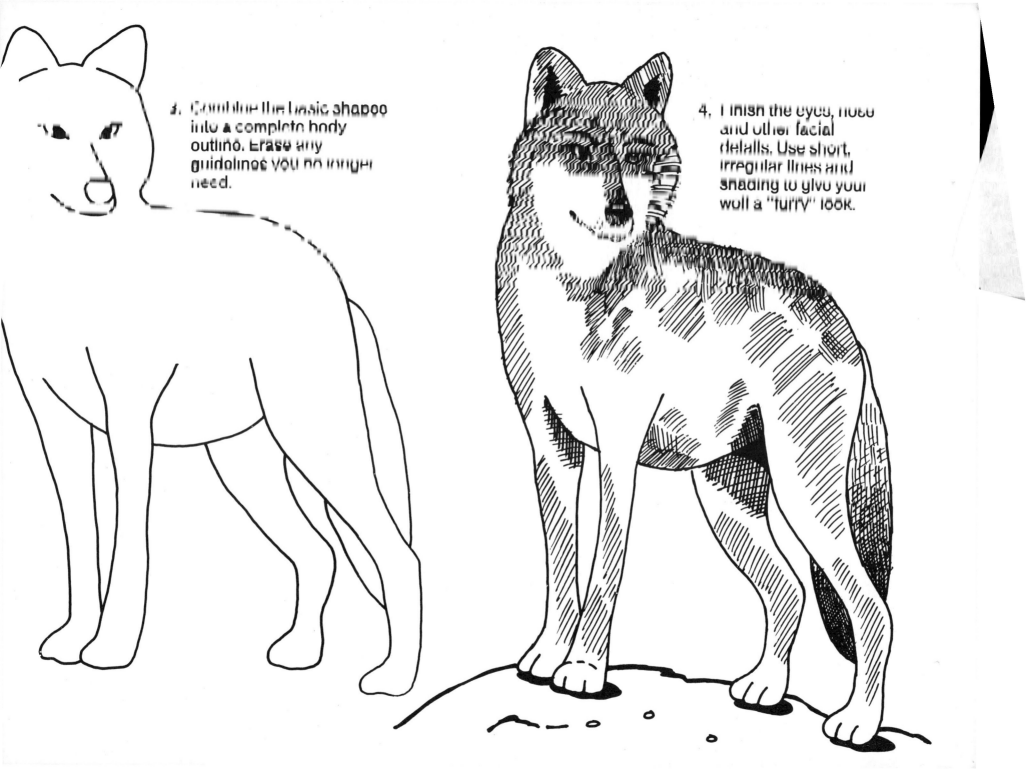

3. Combine the basic shapes into a complete body outline. Erase any guidelines you no longer need.

4. Finish the eyes, nose and other facial details. Use short, irregular lines and shading to give your wolf a "furry" look.

Mountain Gorilla

A small area in Africa is the last home of these shy and gentle primates. These great apes live in small groups of 5 to 25 members. They are led by an adult male, called a silverback because of the color of his fur. The rapid destruction of the forests in which they live forces the gorillas to move farther and farther into remote areas.

Flash fact: *There are fewer than 400 Mountain Gorillas in eastern Africa.*

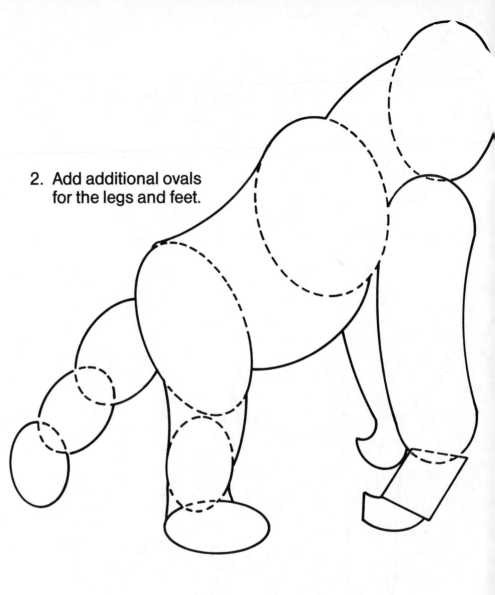

2. Add additional ovals for the legs and feet.

1. Start by drawing three ovals as guides for the head, shoulder area and hindquarters. Connect them to each other. Then add the arms and hands.

Hint: Work on each section of the gorilla separately. If you're not satisfied with the way any part looks, erase it and start over again.

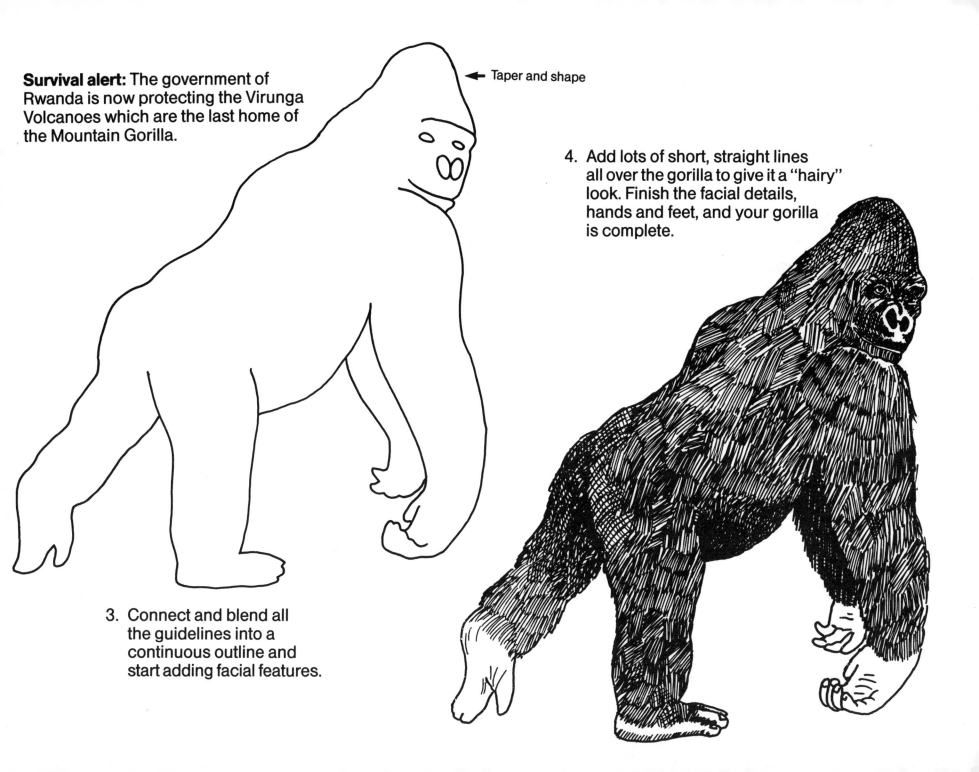

Survival alert: The government of Rwanda is now protecting the Virunga Volcanoes which are the last home of the Mountain Gorilla.

← Taper and shape

4. Add lots of short, straight lines all over the gorilla to give it a "hairy" look. Finish the facial details, hands and feet, and your gorilla is complete.

3. Connect and blend all the guidelines into a continuous outline and start adding facial features.

Scimitar-Horned Oryx

This rarest of antelopes is found in Arabia and the semi-desert areas of the Sahara. By the mid-1980s, due to excessive hunting, this magnificent animal was on the brink of extinction.

Flash fact: *Substantial numbers of these antelopes have survived in captivity. In 1986, a herd was reintroduced to its natural habitat in Tunisia.*

1. Begin the Oryx with two ovals, one for the shoulder area and the other for the hindquarter. The connecting lines between the two ovals form the back and belly. Next, draw ovals and a circle for the head, and connect it to the body.

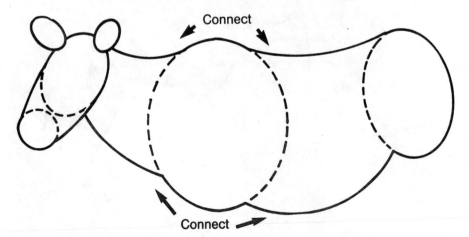

Connect

Connect

2. Add more ovals for the top part of the legs, and connect them to the triangular hooves. Add very long, curved horns and a tail.

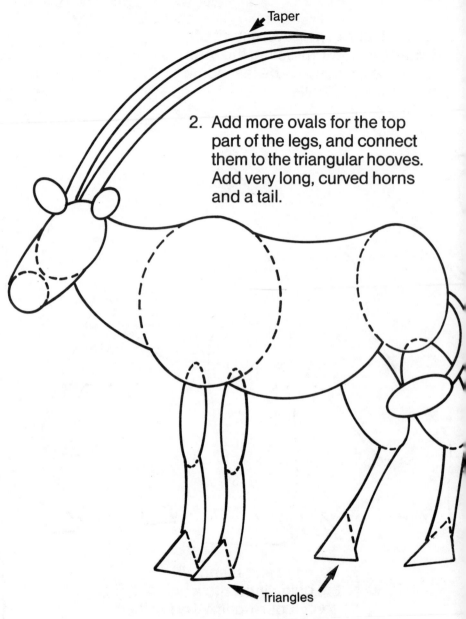

Taper

Triangles

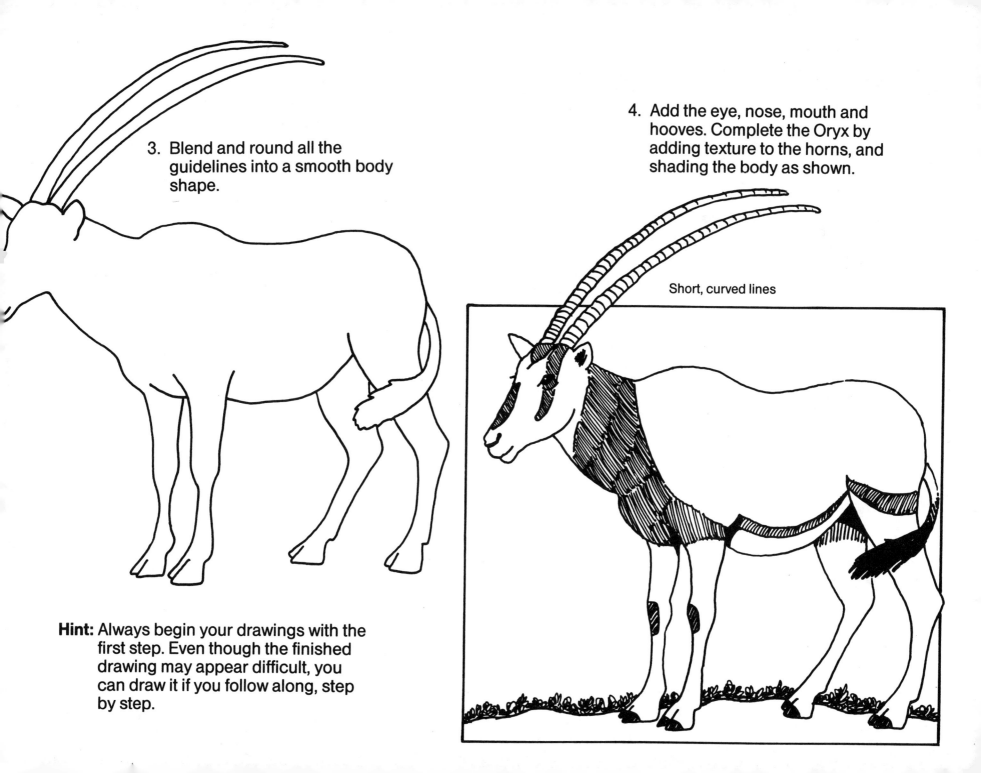

3. Blend and round all the guidelines into a smooth body shape.

4. Add the eye, nose, mouth and hooves. Complete the Oryx by adding texture to the horns, and shading the body as shown.

Short, curved lines

Hint: Always begin your drawings with the first step. Even though the finished drawing may appear difficult, you can draw it if you follow along, step by step.

Tiger

The biggest of all cats, Tigers live only in Asia. A large male can weigh more than 500 pounds and can grow to 9 feet long, including its tail. Although overhunted for its beautiful coat, the Tiger's greatest threat is loss of habitat. There are 5 times as many people living in the areas roamed by Tigers than there were in 1900.

Flash fact: Between 1900 and 1970 about 95,000 Tigers were killed. Project Tiger was started by the World Wildlife Fund in 1973 when there were only 5,000 Tigers left.

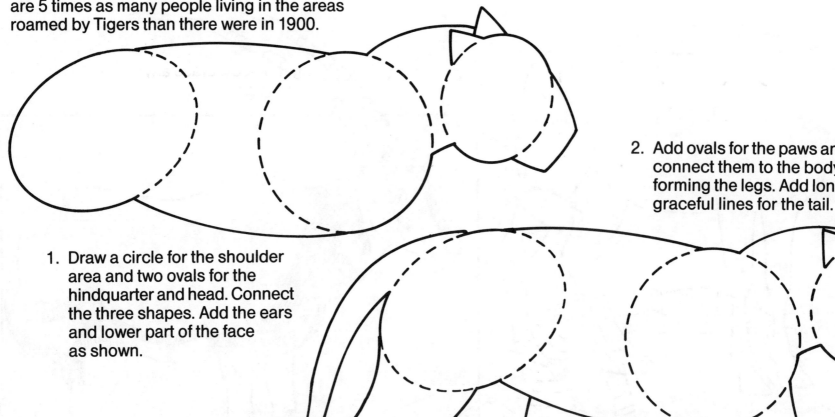

1. Draw a circle for the shoulder area and two ovals for the hindquarter and head. Connect the three shapes. Add the ears and lower part of the face as shown.

2. Add ovals for the paws and connect them to the body, forming the legs. Add long, graceful lines for the tail.

Taper and curve tail

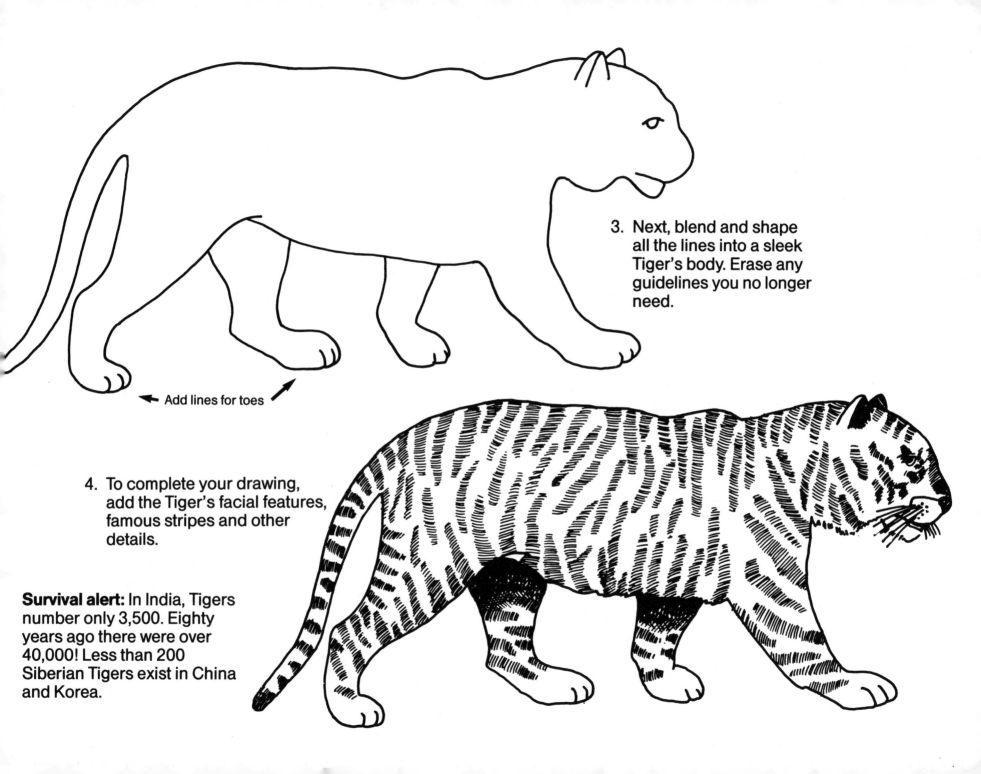

Add lines for toes

3. Next, blend and shape all the lines into a sleek Tiger's body. Erase any guidelines you no longer need.

4. To complete your drawing, add the Tiger's facial features, famous stripes and other details.

Survival alert: In India, Tigers number only 3,500. Eighty years ago there were over 40,000! Less than 200 Siberian Tigers exist in China and Korea.

Galapagos Tortoise

This giant tortoise exists only on the Galapagos Islands, off the coast of South America. It can grow up to four feet in shell length and weigh 500 pounds or more. The Galapagos Tortoise can live up to 200 years—longer than any other animal.

Flash fact: Galapagos Tortoises are now very rare due to overhunting and loss of habitat. In addition, the tortoise's eggs are often eaten or destroyed by other animals.

1. Start with a large oval for the tortoise's shell. Then, add circles, ovals and rectangles for the legs and feet.
Add a small oval for the head and connect it to the shell.

Connect

Add

Curved lines

2. Blend the shapes as shown to form a smooth outline of the tortoise.

Small curves outline the toes

3. To complete your drawing, add the shell pattern, skin texture and some background scenery.

Add facial features

Read about other ENDANGERED ANIMALS at your local library. You'll be able to draw them too if you remember to break the pictures down into simple shapes.